DRUMLINE to DRUMSET

By John Parker

DRUMLINE TO DRUMSET

John Parker

2014

Copyright © 2014 by Phatman Drums

All rights reserved. This book or any portion thereof may not be reproduced or used in any manner whatsoever without the express written permission of the publisher except for the use of brief quotations in a book review or scholarly journal.

First Printing: 2014

ISBN 978-1-312-44401-0

Phatman Drums
4634 E Willow Point Ct
Wichita, KS 67220

phatmandrums.com

Ordering Information:

Special discounts are available on quantity purchases by corporations, associations, educators, and others. For details, contact the publisher at the above listed address.
U.S. trade bookstores and wholesalers: Please contact Phatman Drums Tel: (316) 734-2574 or email john@phatmandrums.com.

To the three women who have inspired my musical career:

Mom, who encouraged me to start my musical journey

Ginger Zyskowski, my first and best drum teacher

My wife, Kim, who supports me in the continuation of my career.

Table of Contents

Introduction .. 9

Chapter 1: Legato Strokes ... 11

Chapter 2: Check Patterns .. 20

Chapter 3: Tap Accent .. 27

Chapter 4: Double Strokes ... 37

Chapter 5: That's It! ... 45

Additional Writing Space ... 46

About the Author .. 48

Introduction

When I was a percussion performance major at Kansas State University, I played in the drumline and also worked quite a bit on my drumset playing. It was during that first year of college that I became so acutely aware of the relationship between drumline concepts and drumset concepts. It was also the first time I started self-diagnosing my playing and writing my own exercises to fix my weak spots. Those two concepts are the crux of what has become this book. I can never truly express how much playing tenors on a drumline helped my drumset playing and how a dedicated exercise/warmup routine changed my approach to the instrument and to practicing. I didn't really start to "get better" until I merged all of these concepts together and started formulating who I was going to be as a player.

What This Book Is and What It Isn't

This book will walk you through the steps I took to become a faster, more creative, and tastier drummer. When applied discreetly in the right playing environments, the lessons taught in this book can take you to any level of drumming you want to achieve.

This book is not a method book, but merely a jumping off point. It's a conceptual philosophy. Any successful outcomes you experience after going through this book, will be as a result of your ability to apply these lessons to the way you approach the drums. This book represents Step One of your journey . . . the rest is up to you.

How to Use This Book

Each chapter of this book focuses on one basic drumline exercise that I'm sure every high school drumline has seen before. I give you the entire score for the exercise just exactly how I like to use it with the drumlines that I coach.

Then we'll isolate parts of the exercise and translate them directly to the drumset; first just on a snare and then all over the drumset. Keep in mind that you need to continue to "mark time" with your feet while you play the exercises on the drums. To accomplish this, I just play quarter notes back and forth between my kick and hi-hats.

Finally I'll give you some ideas for applying the exercise to grooves and fills in realistic ways.

Progress Charts

After each of the exercises, I've given you a little progress chart so you can track how fast you can play all the exercises. Please use these as they are a great way to see how far you've come and to keep yourself motivated as you practice.

Write Your Own Exercises, Grooves, and Fills

I've also given you plenty of room to write your own exercises. I'm a huge proponent of writing "custom" exercises to help with specific problems. As you work through the exercises in this book you'll probably find certain "glitches" in your playing that aren't

addressed. Or you may find that the exercises that I've written don't really flow with the way you set up your drums. That's cool! Just use the spaces provided to come up with your own exercises – custom built just for you!

Also, the grooves and fills I've written are just a starting point. Take the ideas I've given you and expand on them with your own ideas. Think about how these techniques can influence the grooves and fills you already play.

Make the Met Your Friend!

Obviously with the way the progress charts are designed, and the way the groove/fill examples are laid out, you need to practice with a metronome. For a drumset player, there's no skill more important than the ability to keep a steady groove. And metronomes can really help when you're having problems landing a certain lick just right. Please use a metronome with a nice set of earphones when you practice this book, or anything else for that matter!

Notation Keys

Drumline

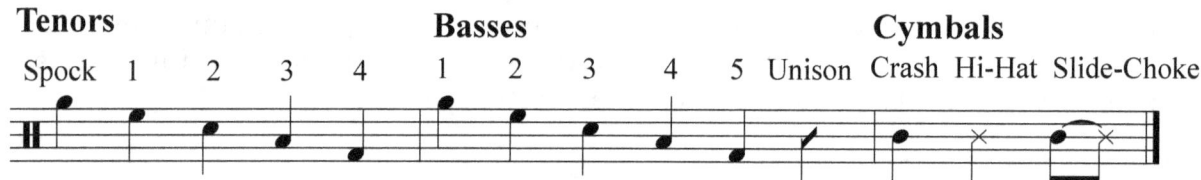

Drumset

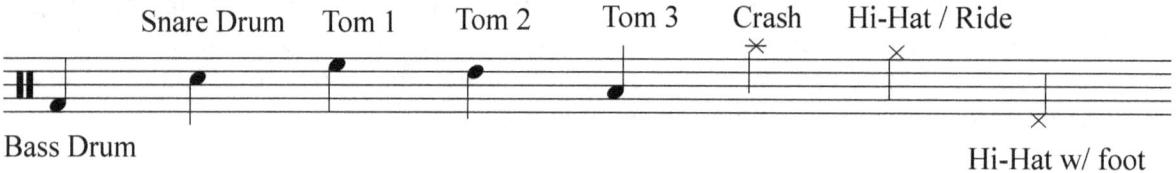

Chapter 1: Legato Strokes

Every drumline has some form of a legato stroke exercise (usually referred to as 8 On A Hand or something similar). The purpose of the exercise is to isolate each hand in a constant motion to build up single stroke rolls. It also stretches the players' hands and gets the line to listen to each other and get locked in. The hardest part of the exercise is the exchange from one hand to the next.

But before we go on, let's make sure we have a solid definition for what a legato stroke is.

> **Legato Stroke:** A smooth, flowing motion that starts high above the drum, travels downward to strike the drum, and finishes at it's original position high above the drum. This stroke is also called a Full Stroke.

If we were to draw a picture of what a legato stroke looks like, it might look something like this:

The important thing to remember is that the motion of the stick should never stop, it should only change directions. When playing true, fluid legato strokes, the player should never physically raise the stick after the first note is played. Instead the force of the rebound of the stick off the drumhead should be utilized to bring the stick back into the original position. Think of it like dribbling a basketball. You don't pick the ball up each time it hits the floor. Instead, you let the ball bounce back up to your hand. The same concept hold true for legato strokes.

> Make sure the motion of the stick is controlled by your wrist and fingers only!
> No arm muscles should be used to play legato strokes.

Goals for Playing Legato 8's
1. Stay Relaxed
2. Push your tempo
3. Even playing (no accents)

Here's the dumline version of the exercise that I like to use (inspired by Tommy Igoe's Great Hands for a Lifetime DVD).

Legato 8's

John Parker

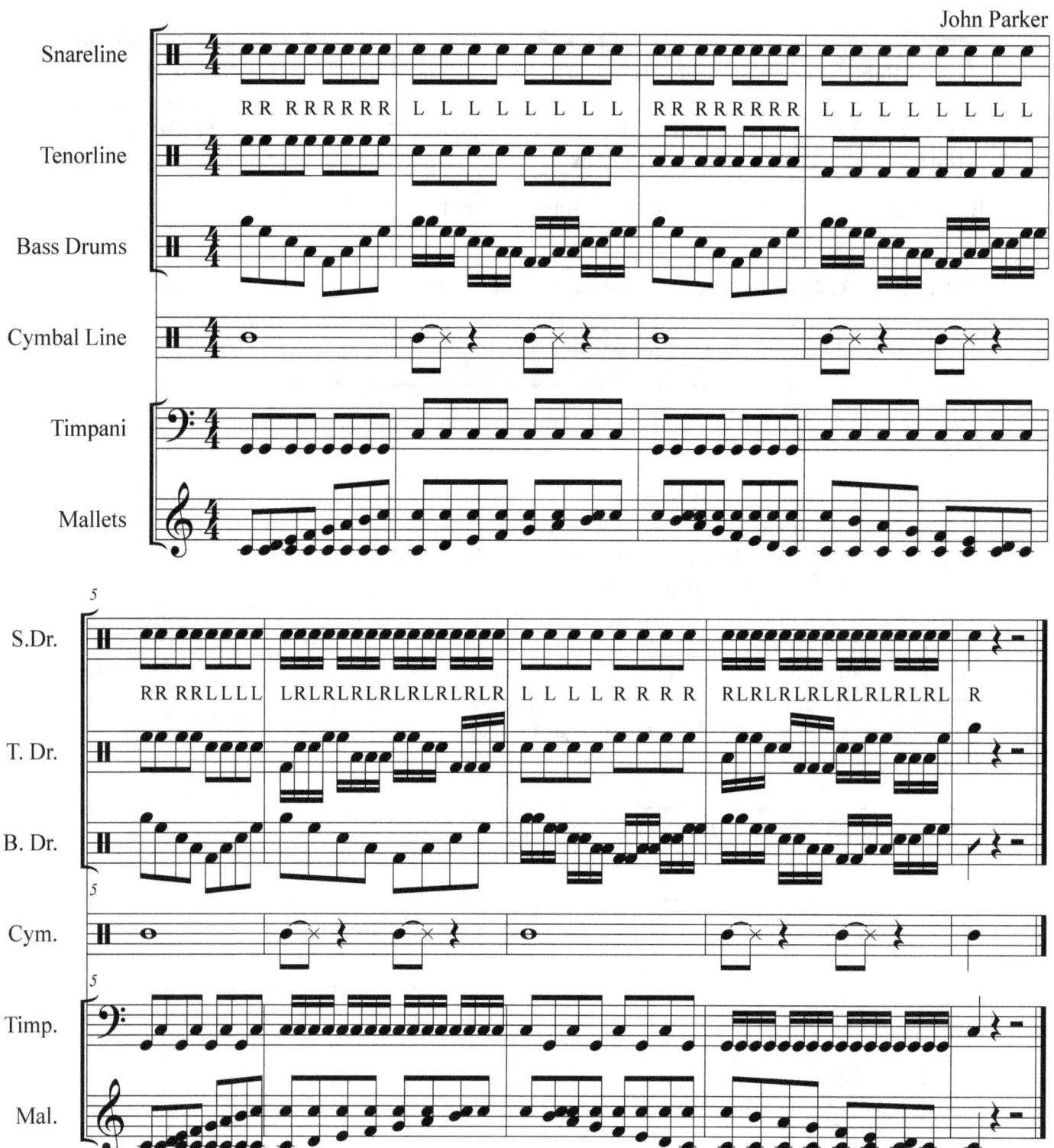

Drumset Application

To apply this exercise to the drumset, we can first start playing the snare line as written over a "walking" foot pattern (like marking time, only backwards).

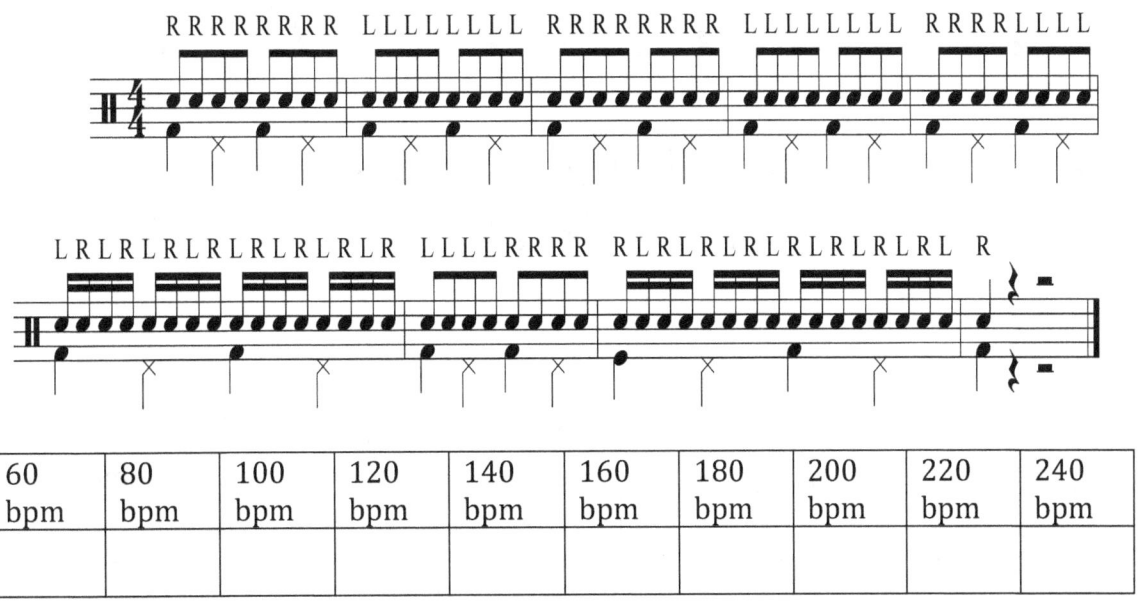

60 bpm	80 bpm	100 bpm	120 bpm	140 bpm	160 bpm	180 bpm	200 bpm	220 bpm	240 bpm

Once you're comfortable with playing this on a single surface, it's time to begin to move the idea around to the rest of your drums. But wait! We need to make sure we're clear on what changes when we go from a single surface to multiple surfaces. Here's the key:

> When moving from drum to drum, make sure that the wrist/fingers hit the drum (up and down motion) but the arm moves the stick to its new target (side to side).

Tenor (quads/quints) player should already be familiar with this concept. It can be tempting when moving around the drums (especially at fast tempos) to change our hand technique in order to facilitate quick movement. **Don't!** Doing so will sacrifice the quality of sound out of the drums and lead to other complicating motions as we try to reset our technique.

Instead, keep your hands moving vertically and use your arms to move from drum to drum. Tenor players call this the X & Y axis of drumming (uh oh . . . we just drifted into geometry).

Alright, with that explanation out of the way, try these ideas to work on your drum to drum movement.

Drumset 8's Variation 1

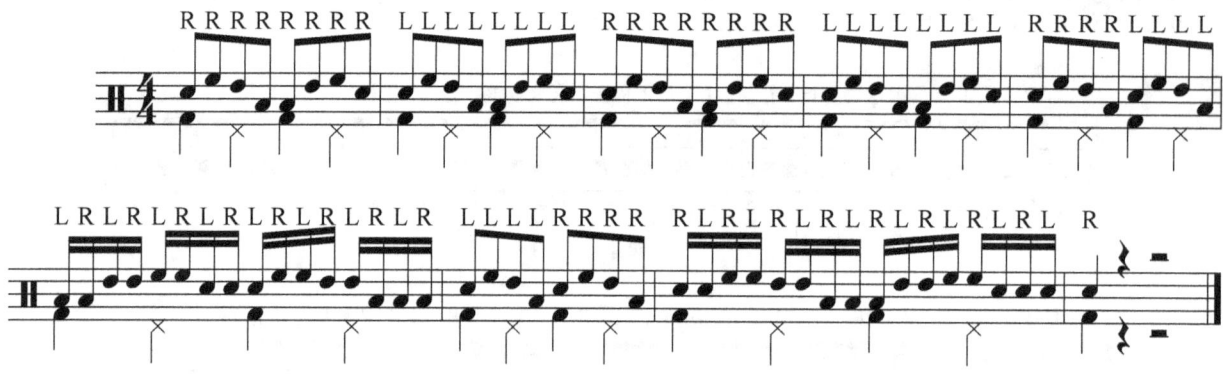

60 bpm	80 bpm	100 bpm	120 bpm	140 bpm	160 bpm	180 bpm	200 bpm	220 bpm	240 bpm

Drumst 8's Variation 2

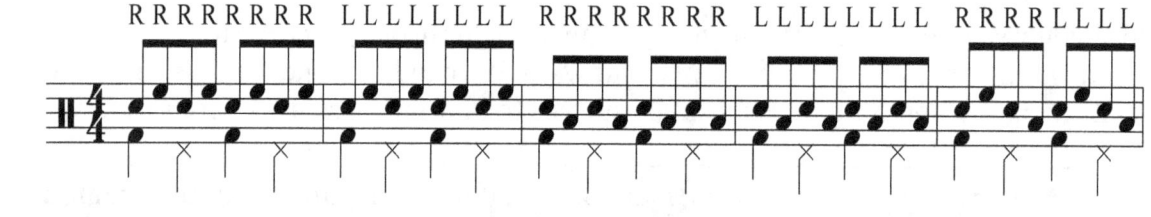

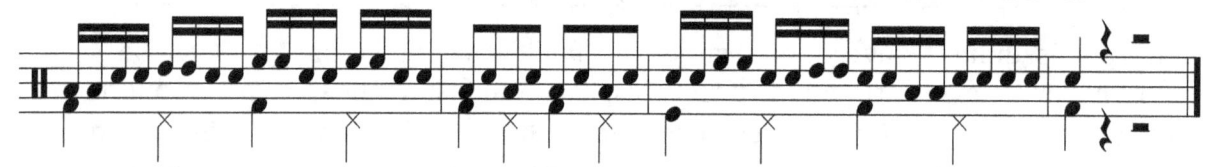

60 bpm	80 bpm	100 bpm	120 bpm	140 bpm	160 bpm	180 bpm	200 bpm	220 bpm	240 bpm

Once you're comfortable with moving around the drums, try different variation of the pattern on your own. If you have something besides a 5 piece kit, try something that fits your kit. Or try moving around the drums in groups of 3, 4, 5, or more. Write your favorite ideas below:

Write Your Own Exercise

Practical Application

The ideas and techniques developed by working on legato strokes in the above exercises have vast applications to different types of grooves.

> Flowing legatos strokes, maintained at a consistent stick height, will naturally lead to solid time keeping as the amount of time needed to execute each stroke should be the same.

We can apply legato strokes throughout the groove as a basis for establishing consistent time keeping, or in short bursts to add flare to a relatively basic groove. Remember to focus on our 3 goals and keep the legato strokes smooth and flowing. Try these ideas to get you started.

1. **Goal tempo = 155 bpm** Apply the legato stroke to the ride patterns in grooves 1 – 4. Focus on maintaining strong technique, without the other limb(s) interfering with the ride.

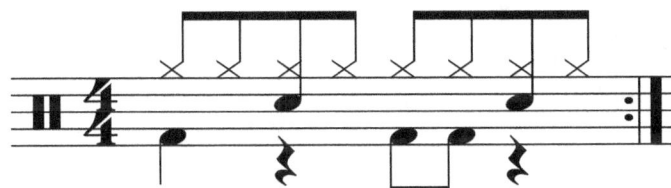

15

2. Goal tempo = 100 bpm

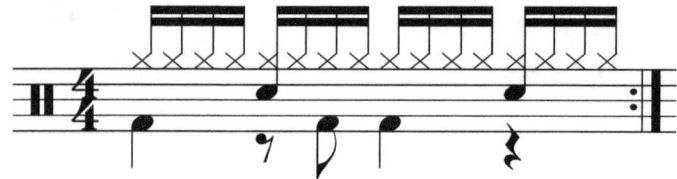

3. Goal tempo = 140 bpm

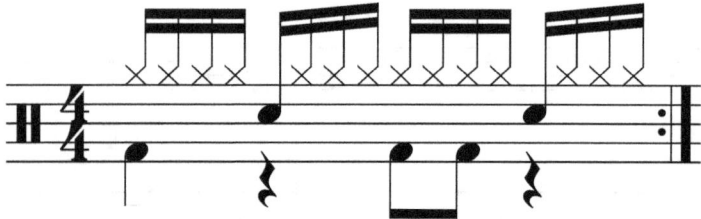

Goals for Playing Legato Strokes

1. Stay Relaxed
2. Push your tempo
3. Even playing (no accents unless indicated)

4. Goal tempo = 130 bpm

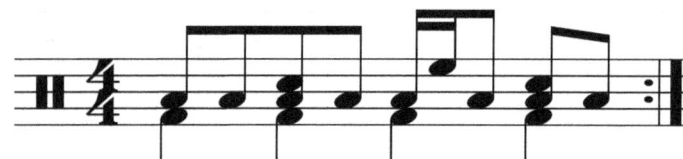

5. Goal tempo = 130 bpm Grooves 5- 8 focus on the moving the ride pattern between multiple surfaces. Use the legato stroke just as we did earlier when we practiced moving around the drums.

Play the floor tom and snare with the right hand, and the high and middle toms with the left.

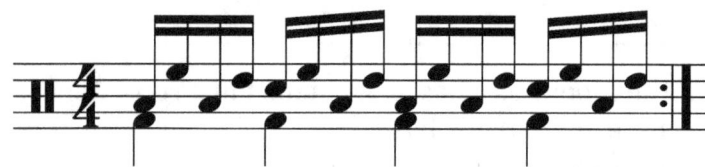

6. Goal tempo = 100 bpm Play the floor tom with the right hand and the hi-hat and snare with the left.

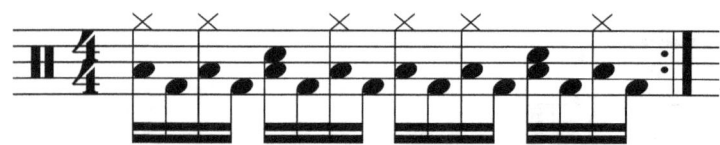

16

7. Goal tempo = 120 bpm Play the ride and floor tom with the right hand and the snare with the left.

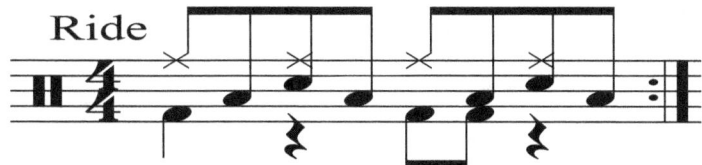

8. Goal tempo = 120 bpm Play the ride and floor tom with the right hand, and the high tom, medium tom, and snare with the left.

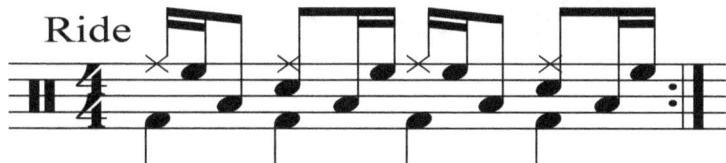

9. Goal tempo = 100 bpm Grooves 9 and 10 focus on adding short bursts of 32nd notes to grooves. Use your legato strokes to achieve a good quality of sound and even tempo when playing these grooves.

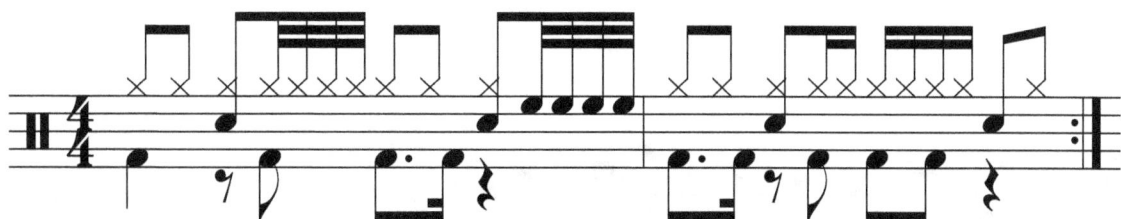

10. Goal tempo = 90 bpm

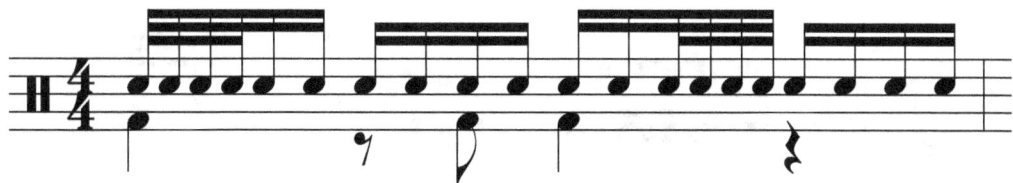

Fills

Of course, we can also use legato strokes as the basis for millions of different fills. Try these to get you warmed up:

1.

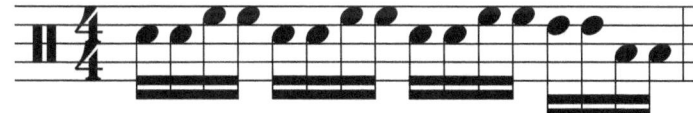

17

2.

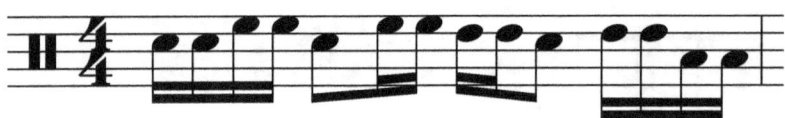

3.

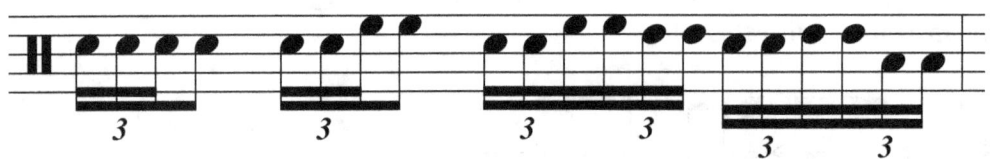

4.

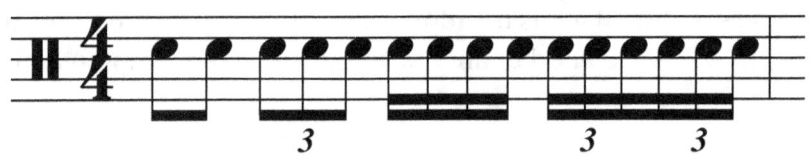

5.

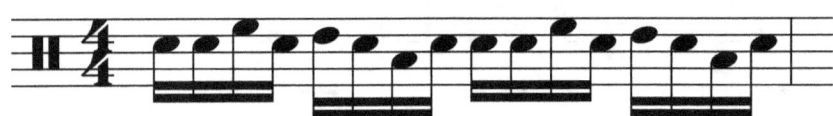

6.

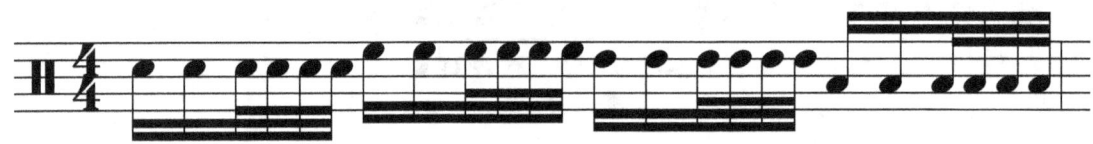

7.

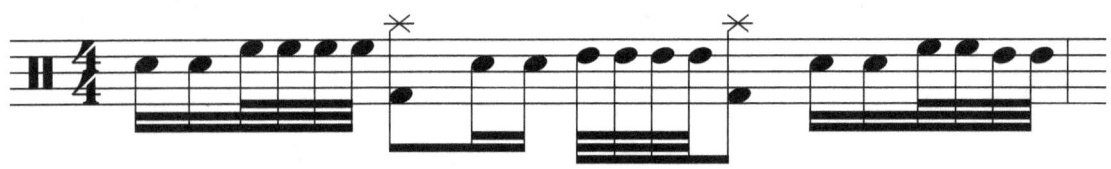

Write Your Own Grooves and Fills

Chapter 2: Check Patterns

Once you've established some nice, fluid single stroke rolls with the legato stroke exercises, it's time to start to break them up with different rhythms. The best way to ensure that we're playing our rhythms with precision is by comparing the rhythm to a "check pattern."

> **Check Pattern:** a basic rhythm that we know we can play well and that can serve as a guide for the more difficult passages.

In the example below, we'll use a solid measure of 16th notes as our check against various 16th note-based rhythms.

We'll use the same goals in this chapter as we used with the Legato Strokes, because we're still using legato strokes. We're just playing them hand-to-hand with different starts and stops applied.

Goals for Playing Legato 8's and Check Patterns
1. Stay Relaxed
2. Push your tempo
3. Even playing (no accents)

> Pay attention to what each hand is playing and find the constant legato strokes that you can "latch onto" as an anchor to keep your playing steady and your rhythms accurate. (For example, in measure 2 below, the right hand is playing constant legato strokes. In measure 6, the left hand is playing constant legato strokes).

Chex Mix

John Parker

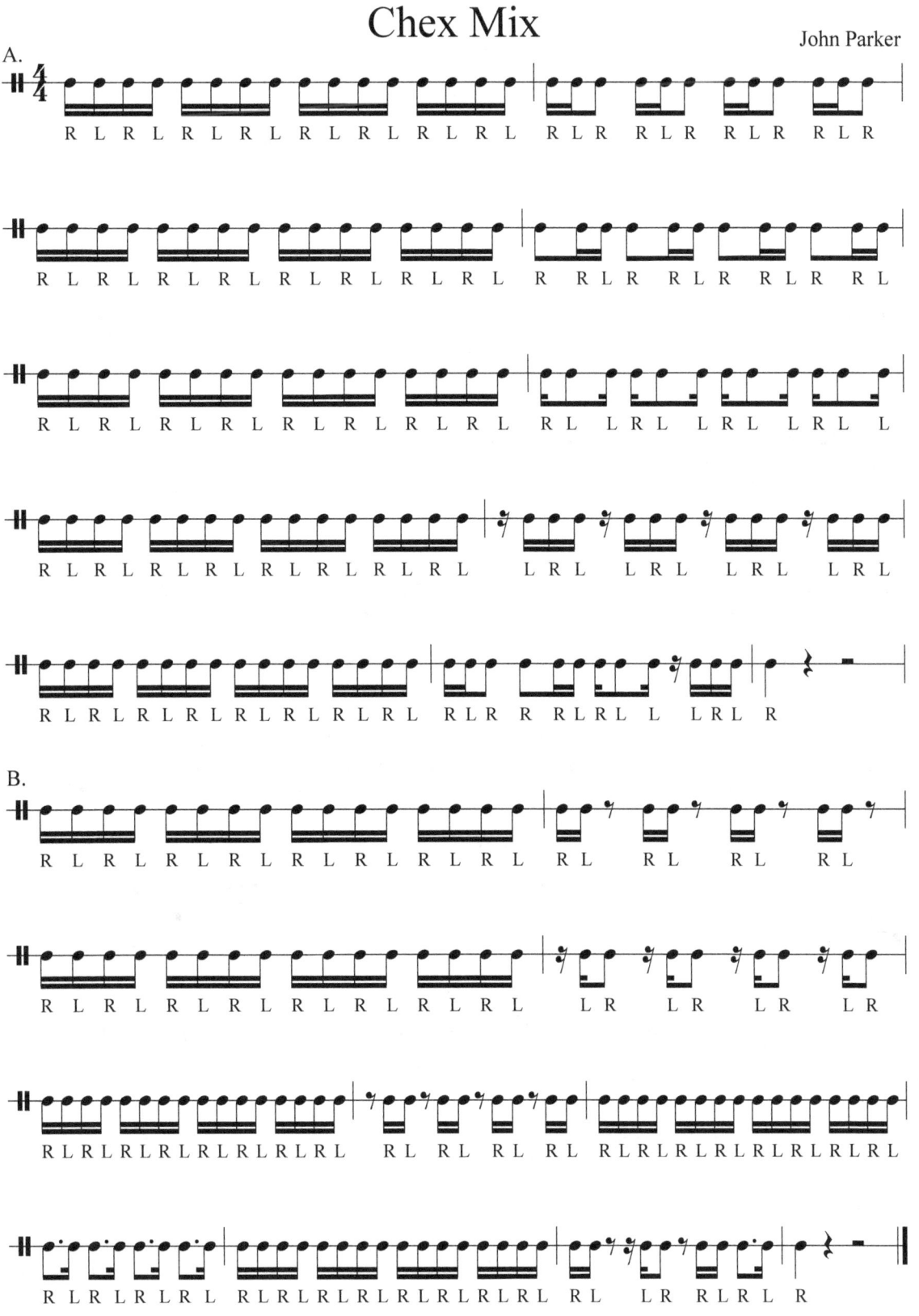

Drumset Application

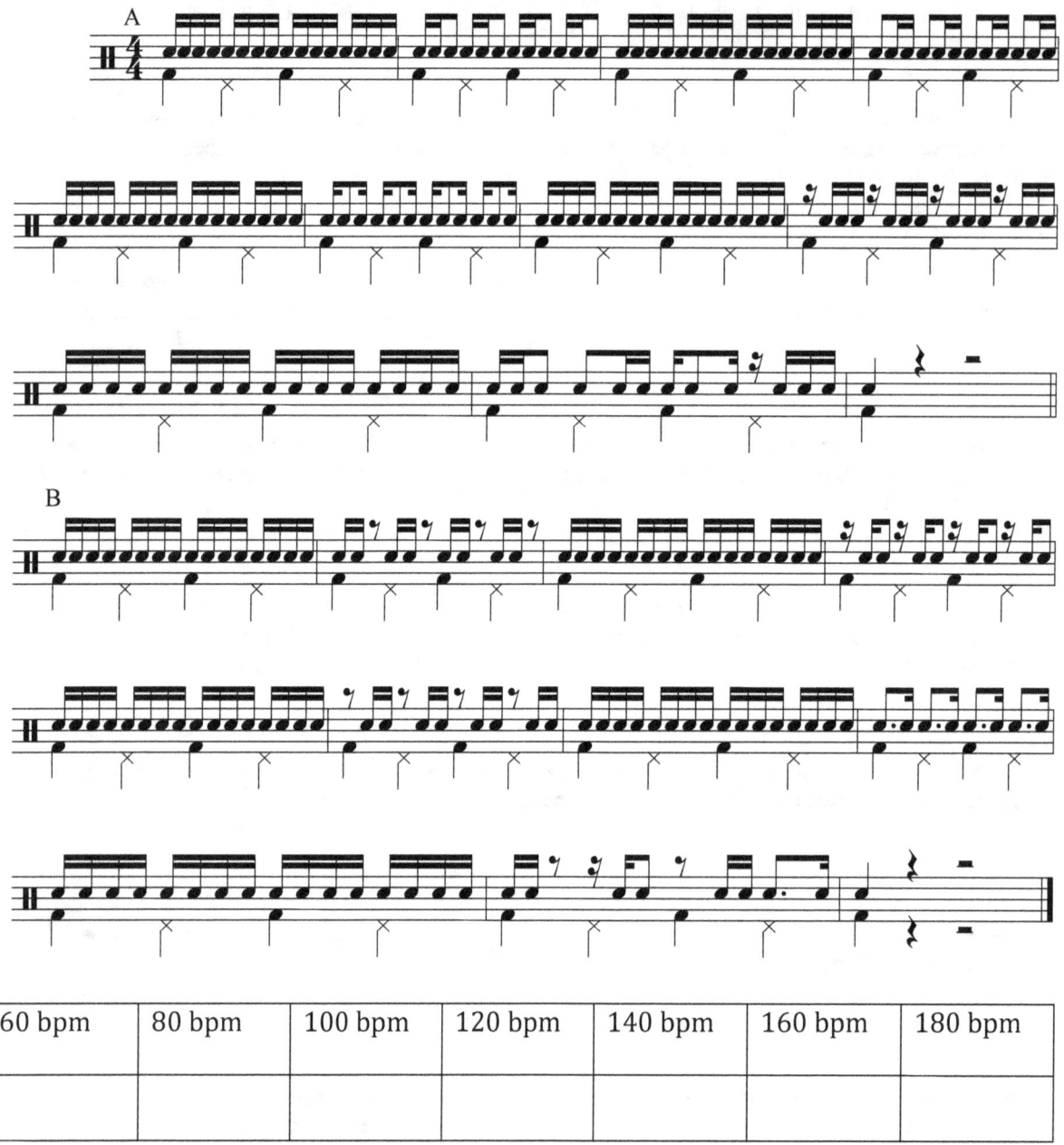

60 bpm	80 bpm	100 bpm	120 bpm	140 bpm	160 bpm	180 bpm

Drumset Variation

For this variation, we'll move the exercise to the hi-hat and add a snare drum back beat to really establish a nice groove. Try playing this exercise hand-to-hand, as well as one-handed. This one can really start to develop the kind of flowing 16th note grooves that Carter Beauford of Dave Matthews Band is famous for.

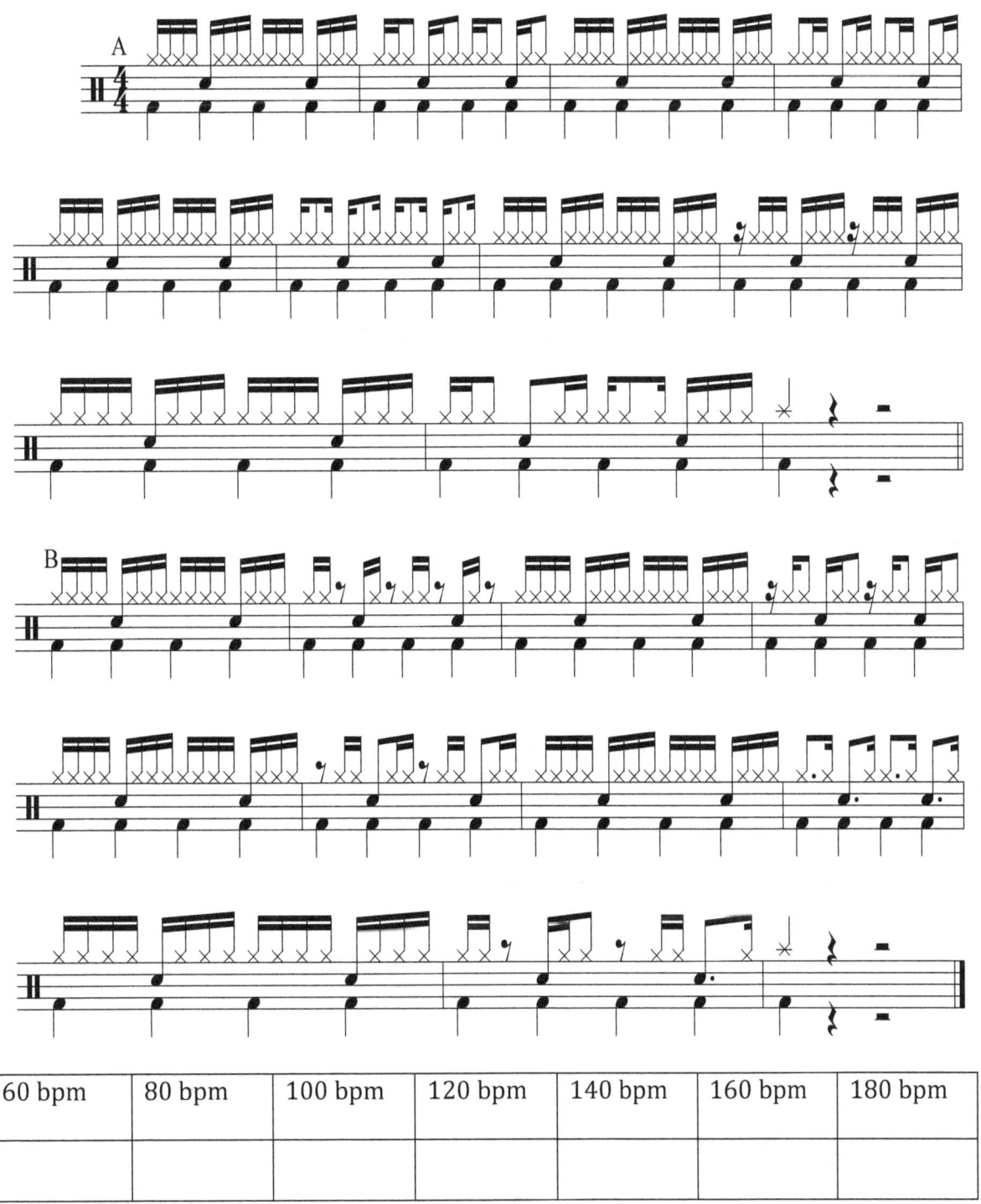

60 bpm	80 bpm	100 bpm	120 bpm	140 bpm	160 bpm	180 bpm

Write Your Own Exercise

Practical Application

Once you've mastered the basic exercise based around check patterns, you've got the basic tools to play some of the raddest grooves ever recorded. Check out these examples to get you started.

1. Goal tempo = 124 bpm In exercises 1-3, concentrate on the smooth flowing legato strokes found in each rhythm. Don't let the accents or hi-hat splashes get in the way of the rhythmic accuracy.

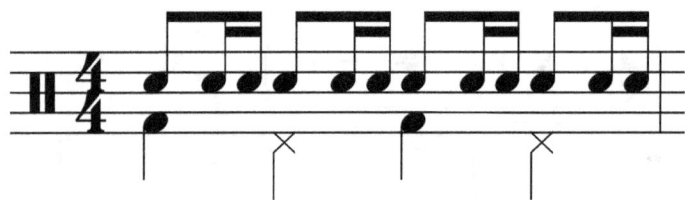

2. Goal Tempo = 128 bpm

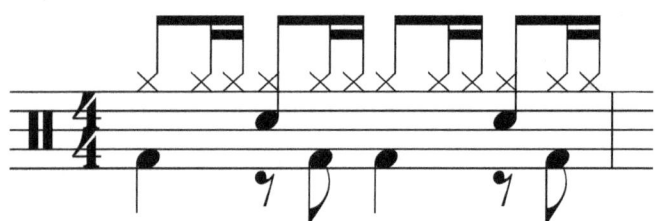

Goals for Playing Legato Strokes & Check Patterns

1. Stay Relaxed
2. Push your tempo
3. Even playing (no accents unless indicated)

3. Goal tempo = 128 bpm

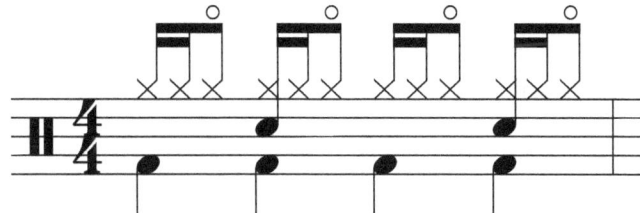

4. Goal tempo = 120 bpm In this exercise, the right hand moves from the hi-hat to the snare, while the left hand fills in the ghost notes. If this one gives you trouble, try practicing the hands together on one surface before splitting them on their respective instruments.

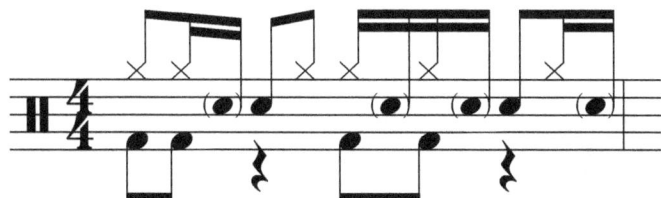

5. Goal tempo = 90 bpm Play this exercise with the right hand devoted to the hi-hat and the left hand playing snare.

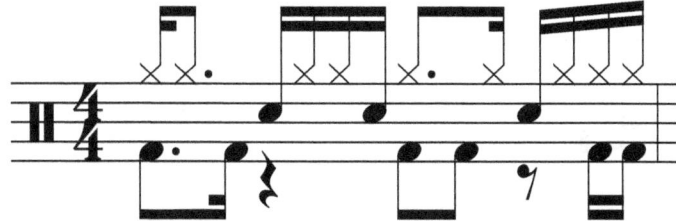

6. Goal tempo = 90 bpm

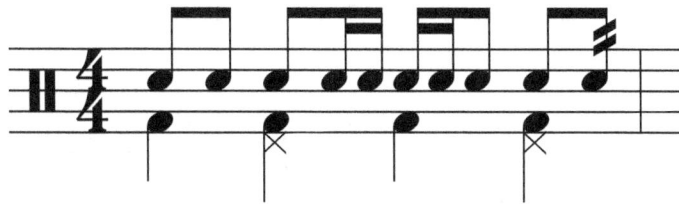

Fills

1.

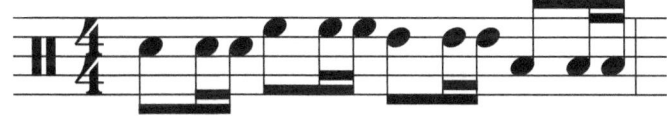

2.

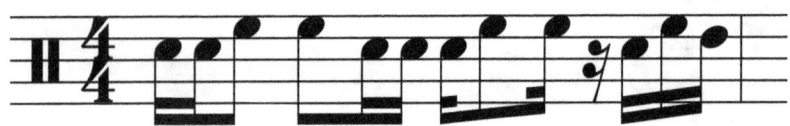

3.

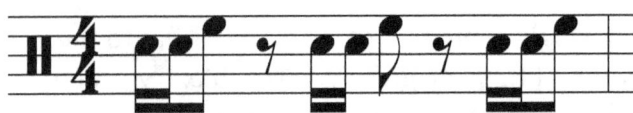

4.

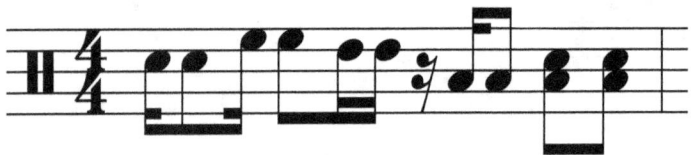

5.

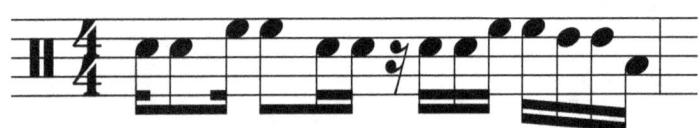

Write Your Own Grooves and Fills

Chapter 3: Tap Accent

The ability to communicate musical concepts using (at least) two stick heights is crucial both to the drumline and to the drumset player. Monotonous drumming becomes mechanical, dispassionate, and boring. Accents and dynamics are essential to making *music* out of what might otherwise be called *noise*. In drumline, we talk about hitting the drum with a consistent intensity and then controlling that intensity at different heights.

> A forte hit on a drum is not *harder* than a piano hit; it is just *higher*. The opposite is true as well for piano hits – *lower* not softer. This concept helps us maintain a good quality of sound at all dynamics.

On a drumset, the same ideas apply, just with a little more gray area. Timbre is a much more flexible thing on a drumset than it is on a tenor line. A drumset *artist* can, and should, explore different sound qualities of all the instruments that make up the drumset. That being said, the ability to control stick heights and communicate accents and dynamics effectively is as vital to being a great drumset player as it is to being a great snare player.

The key to playing multiple dynamics or stick heights is to understand three more strokes, the Staccato Stroke, the Up Stroke, and the Tap Stroke (or Ghost Note).

> **Staccato (or Down) Stroke:** Comprised of the first half of the Legato Stroke. It starts high above the drum but stops just after hitting the drumhead, at a low height above the drum. Think of it like catching the stick just after it produces a sound on the drum.

> **Up Stroke:** The second half of the Legato Stroke. It starts low above the head, makes a short downward motion to strike the drum, and then is brought back up above its original height, much higher above the drum. While the most awkward of the four stroke types to master by itself, it is the most vital as it sets up the player to execute either a Legato or a Staccato stroke.

> **Tap Stroke (Ghost Note):** A very low stroke that starts and finishes at the same low point off the drum. Taps typically require more control to play and thus may require the use of more wrist than fingers. However, faster passages will force the player to open up the hand and let the fingers do more work. Finesse is the name of the game!

Before we take a look at the drumline exercise and how to apply it to the drumset, let's take a very important moment and pause to practice these strokes by themselves. First, here's a look at how we'll note each of the different strokes:

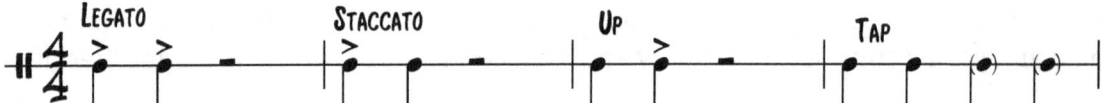

Next, play each of the following exercises one hand at a time (all rights, then all lefts), focusing carefully on the different strokes and how utilizing them will help you naturally play the dynamics indicated.

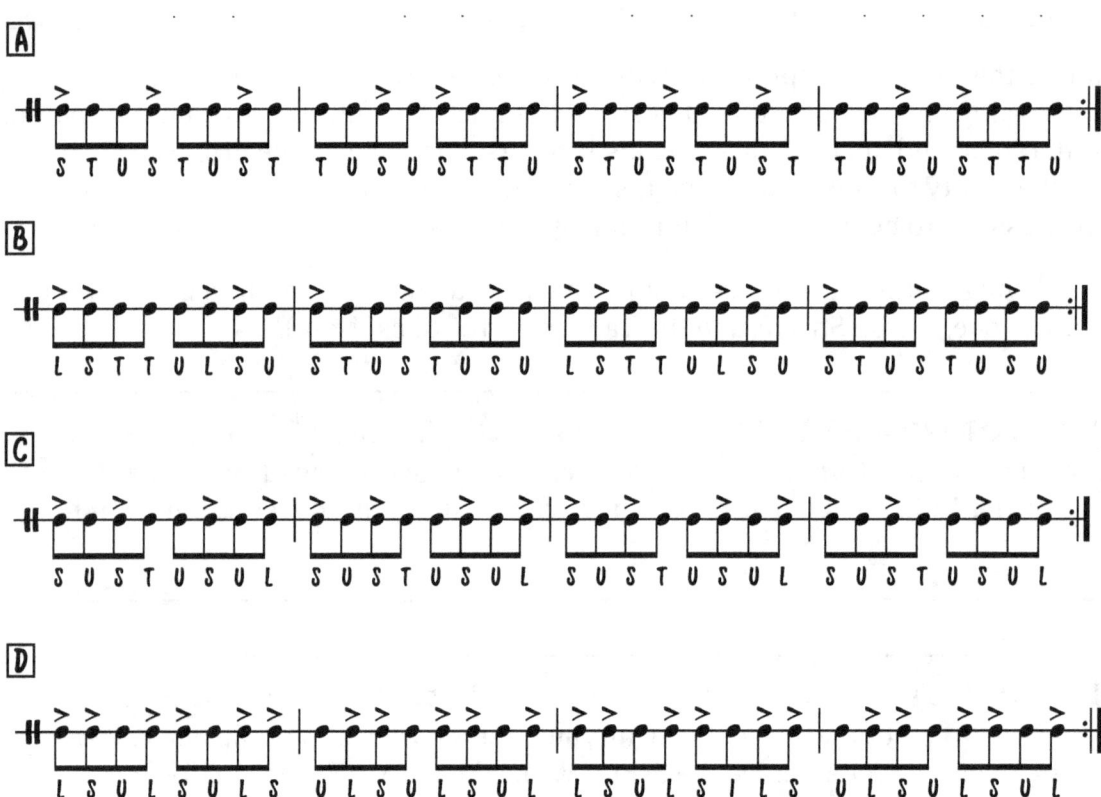

For exercise E, write the types of stroke under the notes and then practice it like normal.

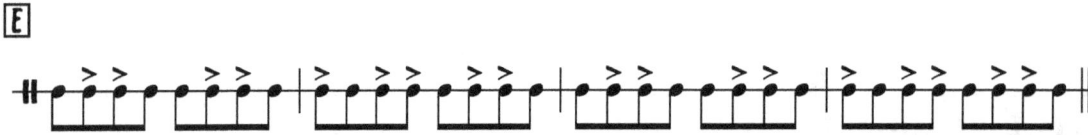

Finally, use the space provided to write out the following stroke pattern:

L S U L S U S U | L S T T L S T T

Now, we can finally get to the Tap/Accent exercise.

Tap / Accent

John Parker

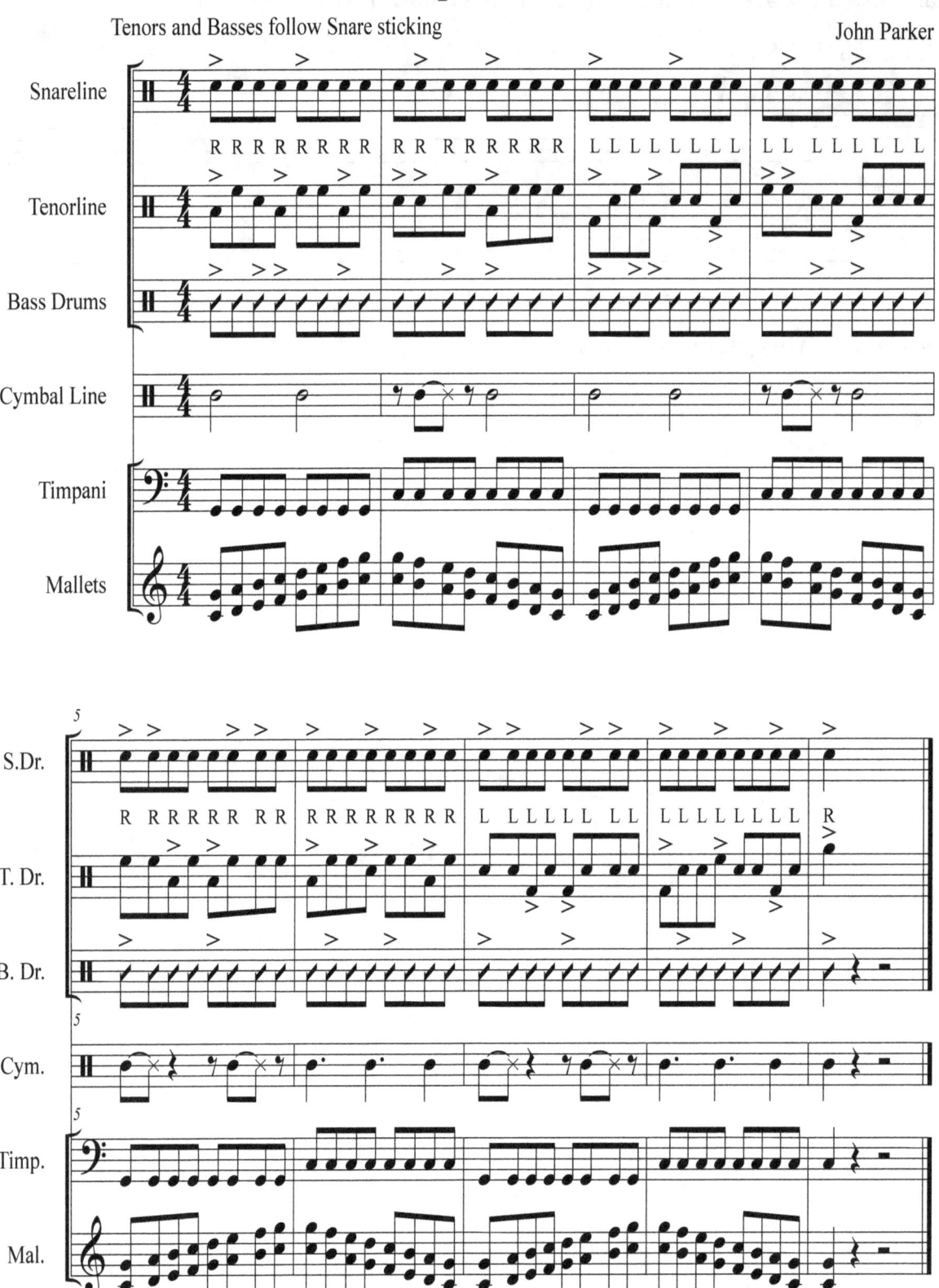

Drumset Application

For a switch we'll try the tenor part!

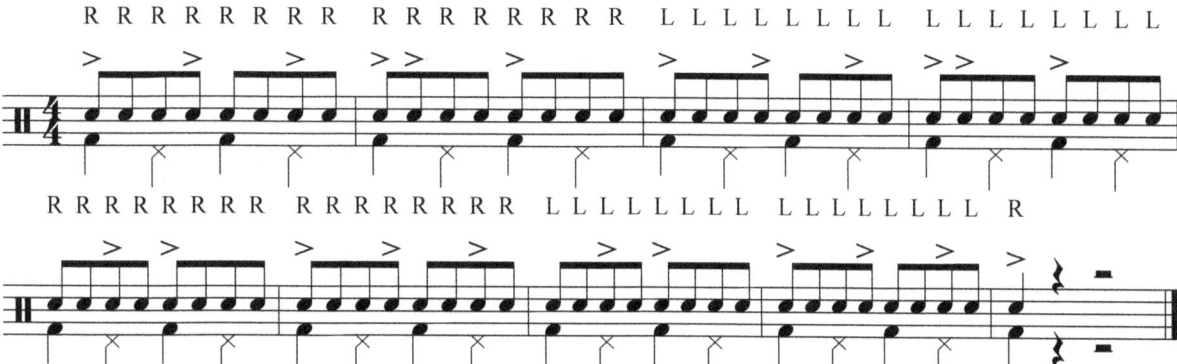

Be sure to practice this at multiple dynamics (*p, mp, mf, f*) and at multiple combinations of taps versus accents (*p/f, mp/f, mf/f, p/mp*).

60 bpm	80 bpm	100 bpm	120 bpm	140 bpm	160 bpm	180 bpm

Drumset Variation 1

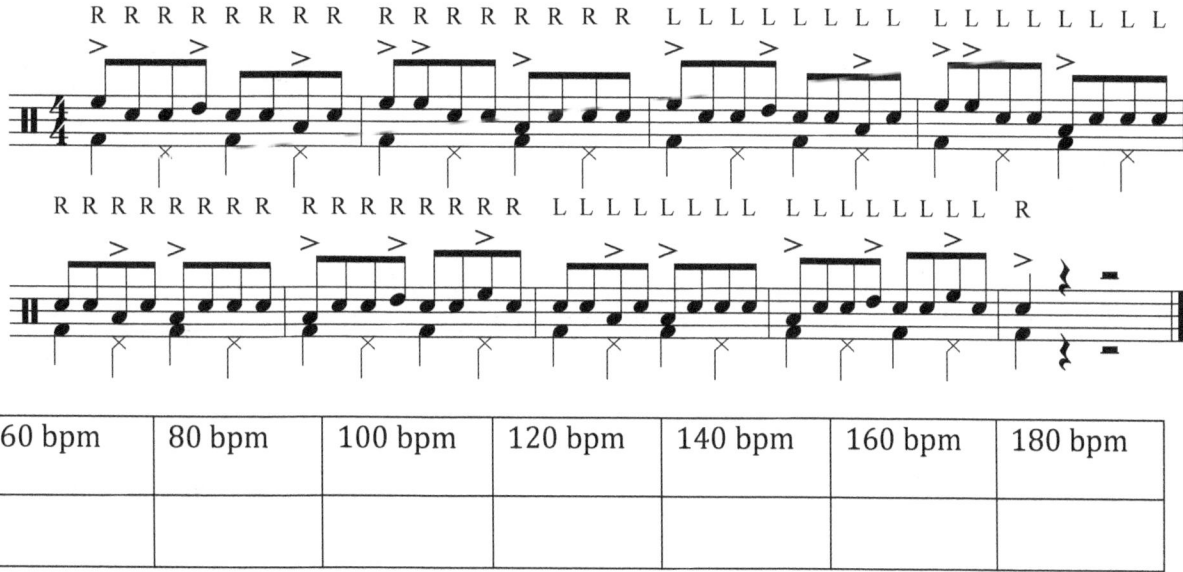

60 bpm	80 bpm	100 bpm	120 bpm	140 bpm	160 bpm	180 bpm

The trick to this exercise is maintaining good stick heights as you move around the kit. Tenor players will know what this is all about. The hardest motion to make is to move from one drum to another at a piano dynamic. If you find yourself struggling with this

exercise, start to isolate the motions one at a time and practice them separately. Then slowly start to put them back together.

Drumset Variation 2

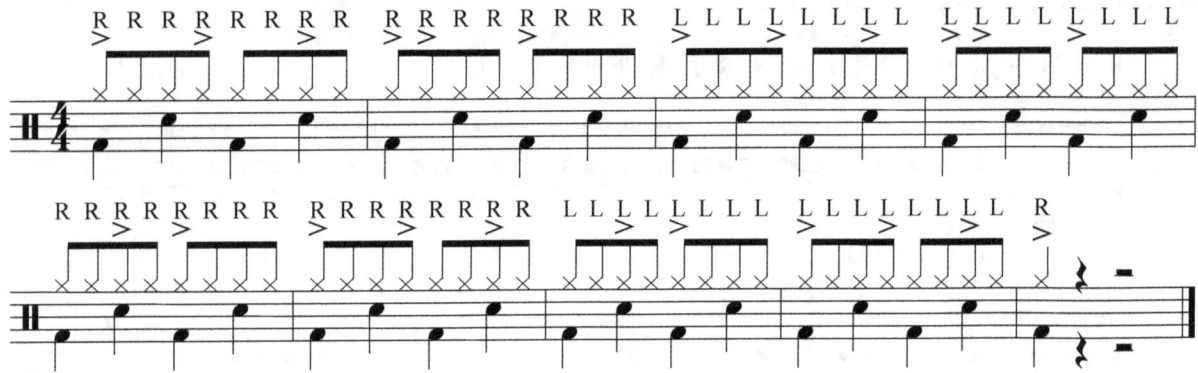

Now we're starting to add some coordination to the concept . . . and finally some groove, too! Take your time here and practice slowly! And don't forget to practice playing the hi-hat with each hand.

60 bpm	80 bpm	100 bpm	120 bpm	140 bpm	160 bpm	180 bpm

Write Your Own Exercise

Practical Application

1. Goal Tempo = 150 bpm Exercises 1-4 demonstrate the basic concept of the 4 different stroke types applied to the drumset. Really strive for a large contrast between the accent and the tap.

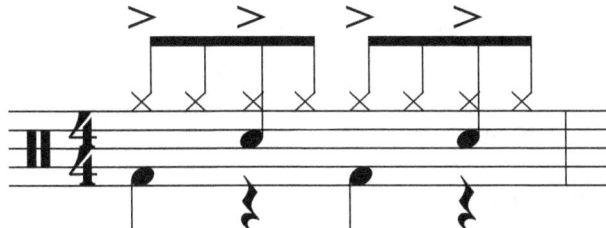

2. Goal Tempo = 150 bpm

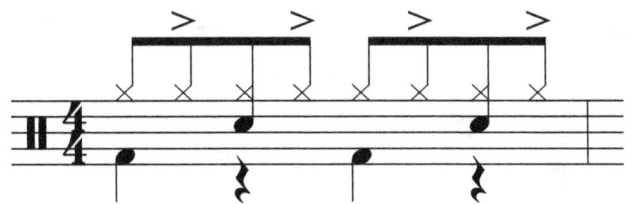

3. Goal Tempo = 127 bpm

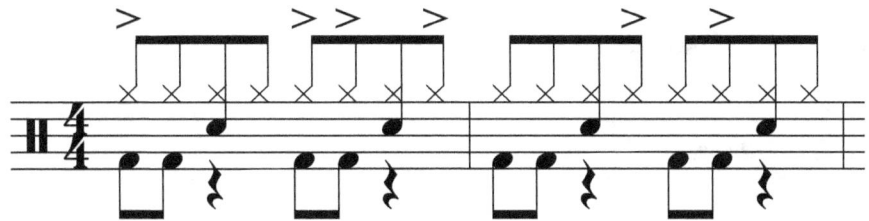

4. Goal Tempo = 140 bpm

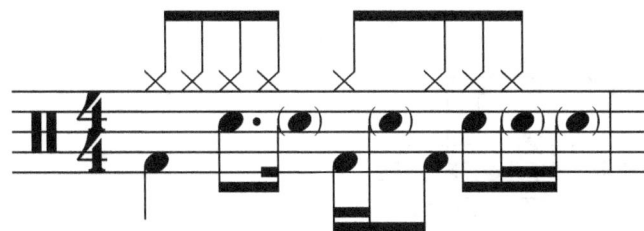

5. Goal Tempo = 170 bpm To play this exercise at the goal tempo, you're going to have to open up your hand and play a bit more legato than you might normally play.

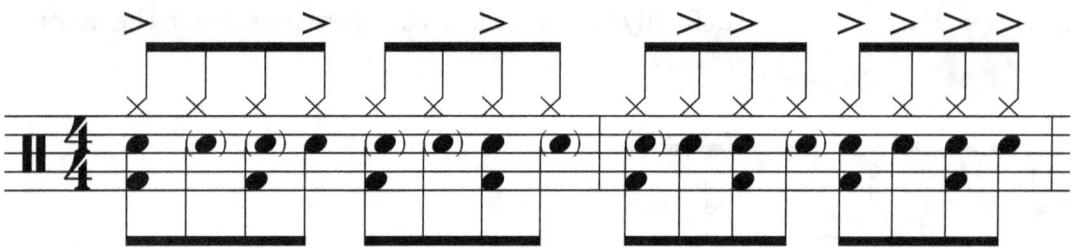

6. Goal tempo = 103 bpm Exercise 6 and 7 both utilize what some drummers refer to as "pull outs," a low tap followed by a very quick accent. Spend some time working just on this stroke combination by itself to help achieve speed and fluidity.

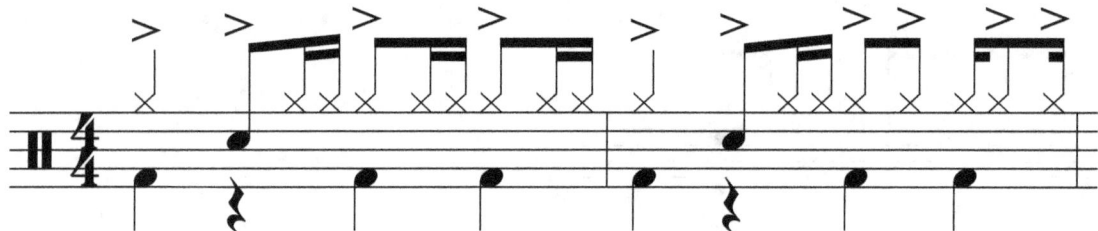

7. Goal Tempo = 200 bpm

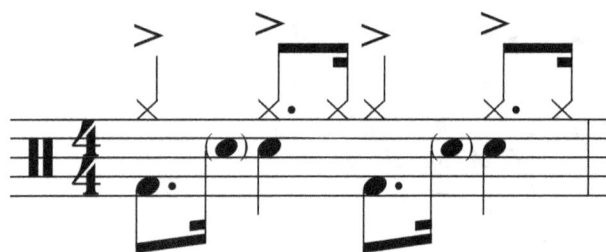

8. Goal Tempo = 90 bpm Feel, feel, feel . . . groove, groove, groove. Really focus on placing the ghost notes exactly where they ought to go and letting the "rolling" triplet feel dominate the groove.

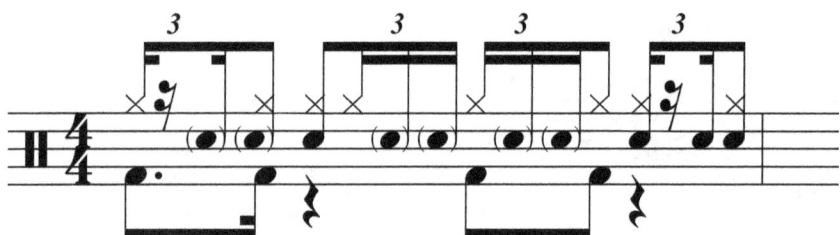

Fills

1.
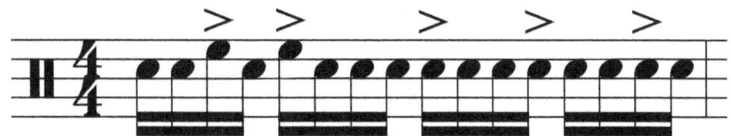

2.
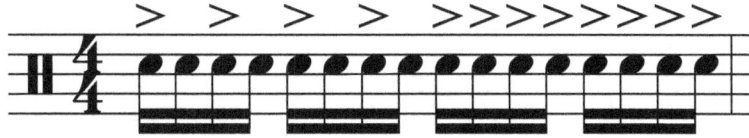

3.
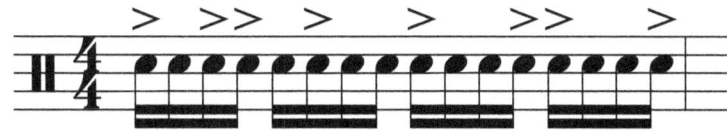

4.
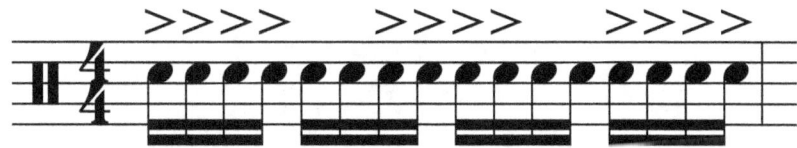

5.
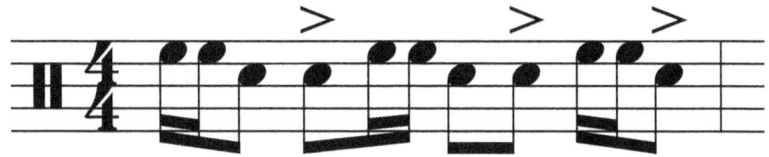

Write Your Own Grooves and Fills

Chapter 4: Double Strokes

The technique for good quality double strokes is not much different than the technique for good quality legato strokes. The first note starts high, the wrist sends the stick downward, and the stick hits the head and rebounds back to the original position. Then the wrist sends it back down again, the stick hits the head and the rebound is caught by the player just after contact. Or, the stick may be allowed to rebound back to its starting position if another stroke is desired.

One question I get asked a lot about doubles is "at what tempo do you stop using your wrist to generate the stroke and start to just let the stick bounce?" The truth is that the premise of the question is wrong. We never just let the stick bounce. That would result in weak, floppy doubles. Instead, the issue is a matter of when do we switch from generating the stroke from the wrist to letting fingers become the driving force in the process. That answer is a matter of chops and tempo. Generally I say to let your wrist drive the stick as long as possible. But somewhere around 140 bpm, the fingers start to take over.

With those thoughts in mind, I recommend you start practicing your doubles at a ridiculously slow tempo in order to analyze the exact motions involved. Use the exercise below as a guide.

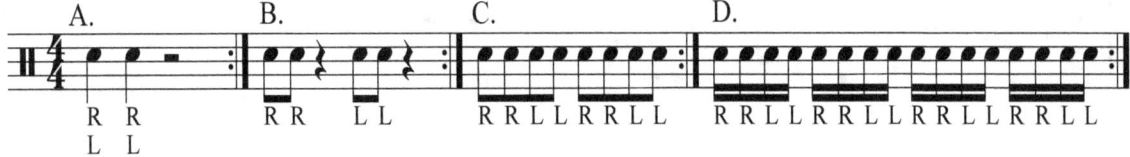

- A. Start by playing just one double, like you would for two 1/4 notes on your right hand. Strive for a consistent sound from the two notes. Now repeat this for the left hand.
- B. Next, play the double as 8th notes and move from hand to hand, but leave space to analyze each double.
- C. Now start to chain the doubles together, still listening very carefully to ensure the notes all sound the same.
- D. Finally do the same thing using 16th notes to really start to get the feeling of a roll.
- E. Only after playing each of these steps should you increase tempo.

Once you feel like you're getting a consistent feeling and sound, begin to tackle the exercises below ... slowly!

Score

Double Beats 2013

John Parker

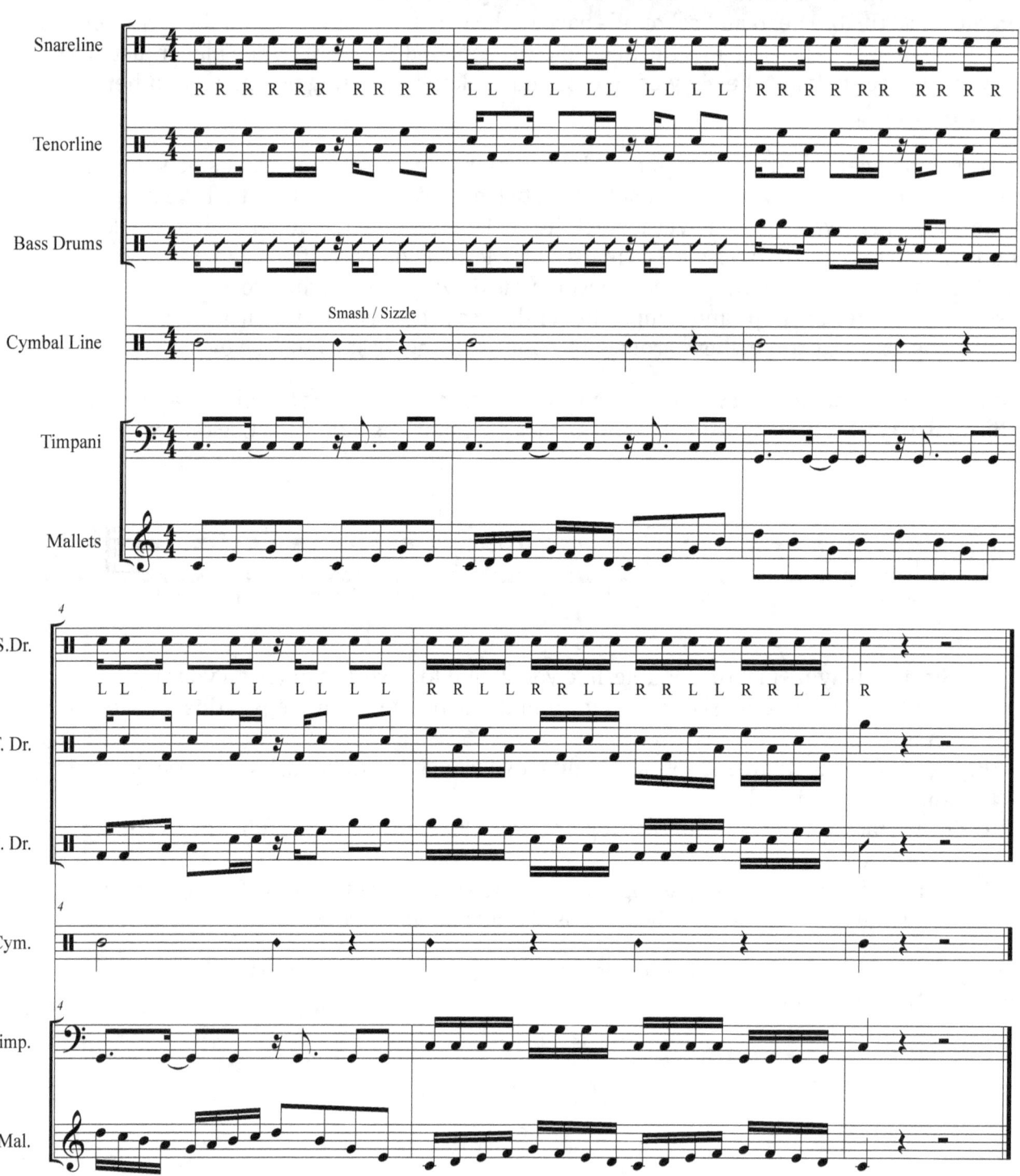

> **Goals for Double Beats**
>
> 1. Consistent sound between each note of the double
> 2. Consistent sound from hand to hand
> 3. Wrist or finger generated stokes, NO BOUNCES!
> 4. Relaxed hands, let the drum do some of the work.

Drumset application

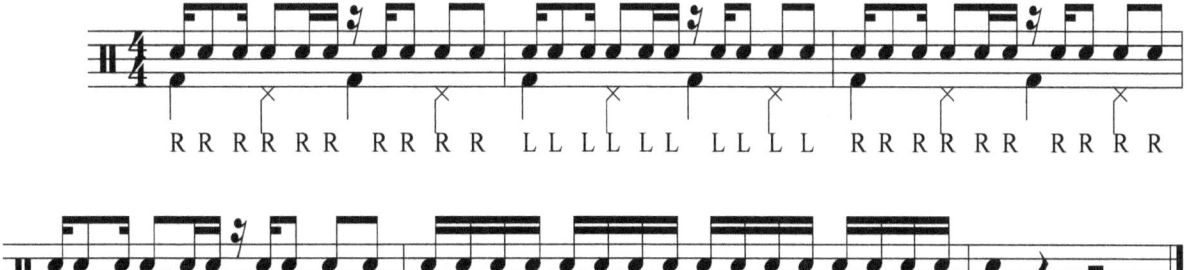

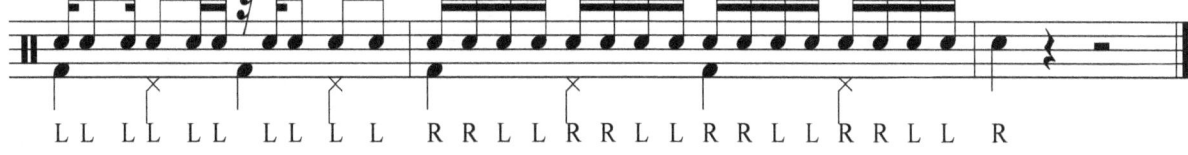

60 bpm	80 bpm	100 bpm	120 bpm	140 bpm	160 bpm	180 bpm	200 bpm

Drumset Variation 1

As you move around the drums, the first thing you'll notice is the inconsistency in rebound from drum to drum. As you descend from snare to floor tom, the drums give less and less energy to restart each stroke. Practically, what that means is that as you move to the larger drums, you have to use more wrist and less finger. Be sure to maintain a strict focus on our goals as you play this one.

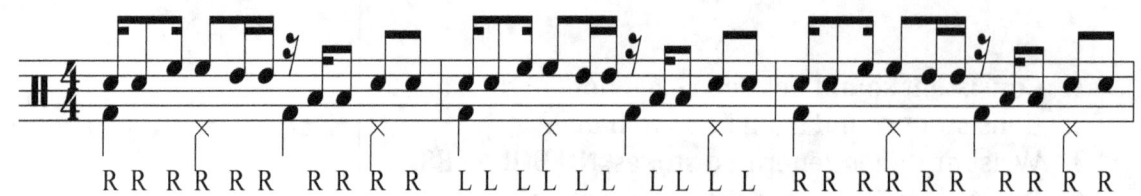

60 bpm	80 bpm	100 bpm	120 bpm	140 bpm	160 bpm	180 bpm	200 bpm

Drumset Variation 2

Now we're getting into the saucy licks. When working sweeps (doubles split between two drums), it's important to revisit the concept of axis of movement that we discussed way back in chapter 1. Remember, the hands only play down to the drums, and the elbow/arm moves the hand from drum to drum.

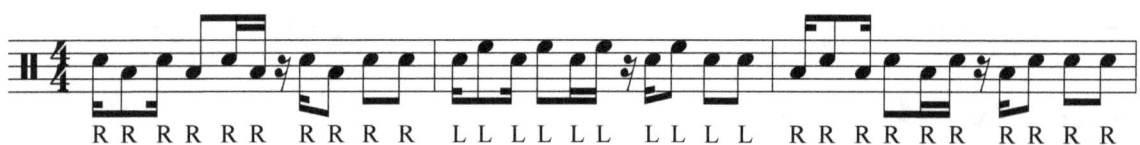

60 bpm	80 bpm	100 bpm	120 bpm	140 bpm	160 bpm	180 bpm	200 bpm

40

Write Your Own Exercise

Drumset Application

1. Goal Tempo 100 bpm

2. Goal Tempo 100 bpm

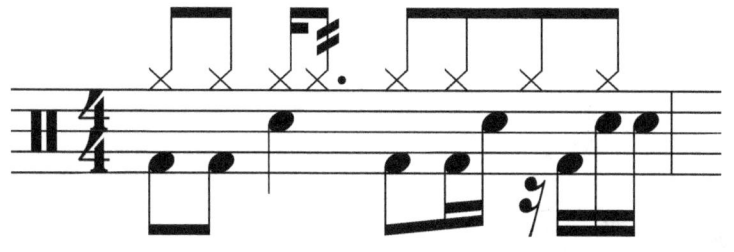

Goals for Double Beats

1. Consistent sound between each note of the double
2. Consistent sound from hand to hand
3. Wrist or finger generated stokes, NO BOUNCES!
4. Relaxed hands, let the drum do some of the work.

3. Goal Tempo 100 bpm

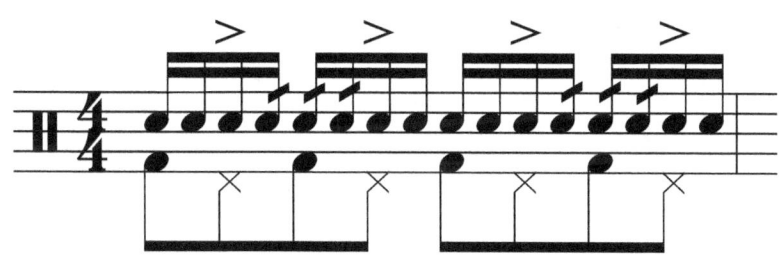

4. Goal Tempo 80 bpm

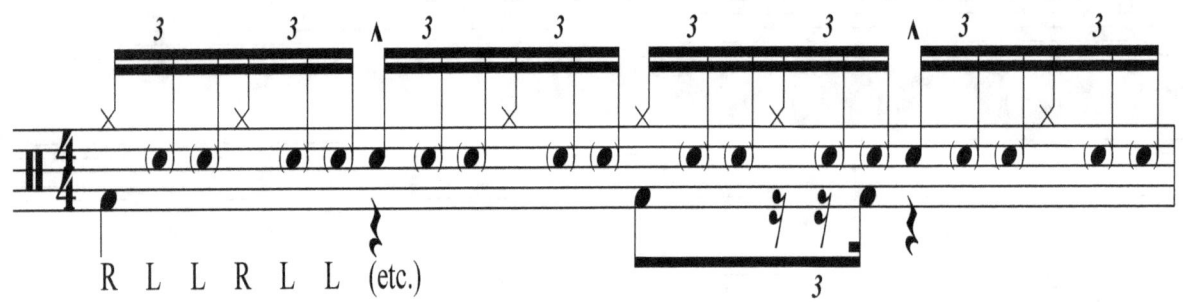

5. Goal Tempo 80 bpm

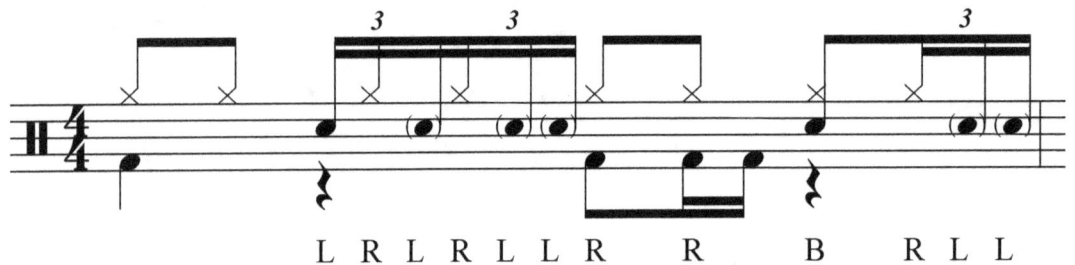

Fills

1.

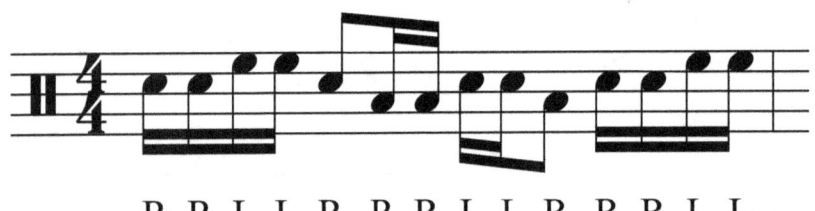

2.

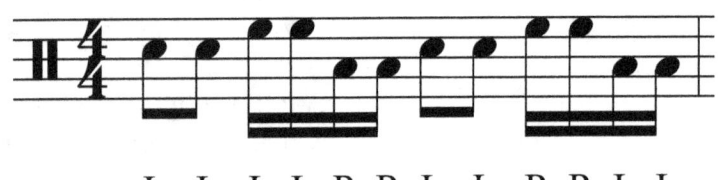

42

3.

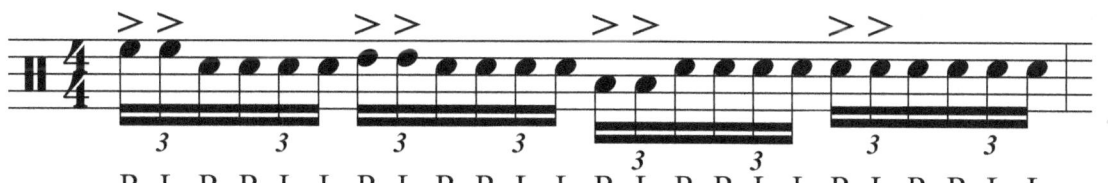

R L R R L L R L R R L L R L R R L L R L R R L L

4.

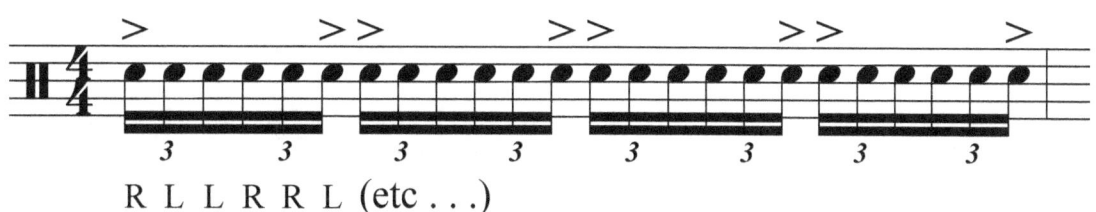

R L L R R L (etc . . .)

5.

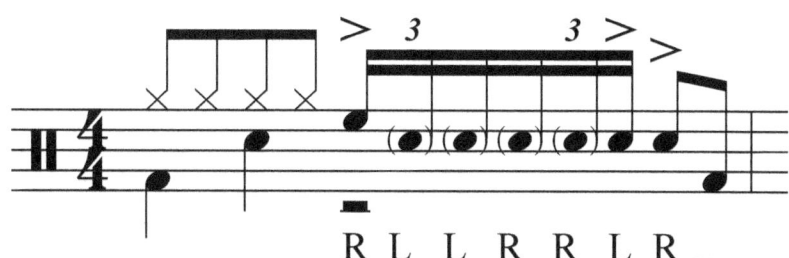

R L L R R L R __

6.

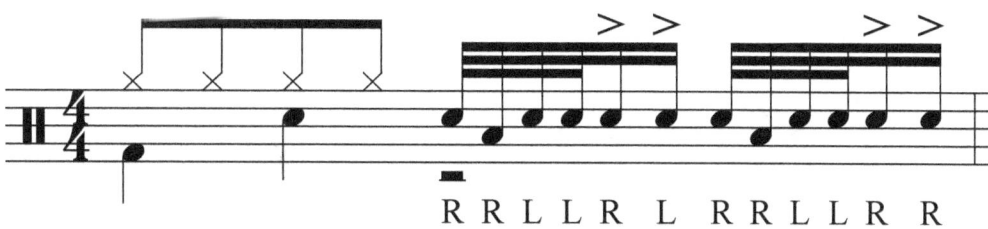

R R L L R L R R L L R R

7.

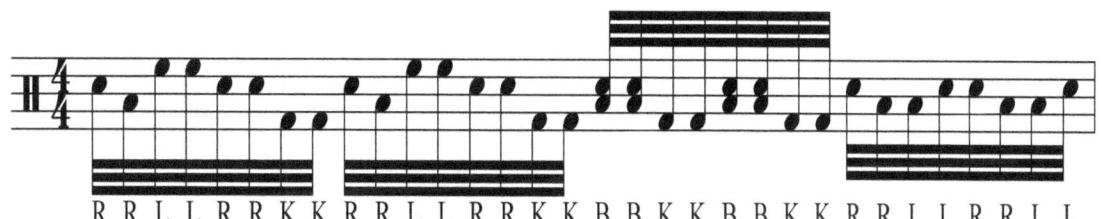

R R L L R R K K R R L L R R K K B B K K B B K K R R L L R R L L

Savvy students will notice that we've started working in paradiddle rudiments and some roll rudiments as well. That totally makes sense, since paradiddles and rolls are just combinations of singles and doubles.

Write Your Own Grooves and Fills

Chapter 5: That's It!

If you've practiced all the skills in this book and been diligent about your quality of sound, you now know everything you need to take your drumline chops and apply them to the drumset.

But the journey's not over. This is just the map to the starting line. You still have to run the race. Think of the things we haven't covered: flams, hybrids, bass drums applications, and so much more. Your job is to take these ideas and expand them into something new. How can you apply these ideas to jazz, latin, or gospel styles? How can you chain them together to make longer solo ideas?

It's all up to you now!

Additional Writing Space

About the Author

John Parker started playing drums and percussion, as most musicians do, in elementary school. After twenty-plus years, he is still addicted to the infectious feeling that only a solid groove can generate. "Drums and drumming are my passion." Now, John is excited to share that passion with the next generation of drummers.

John was educated for ten years at the Professional Drum School in Hutchinson Kansas, directed by Ginger Zyskowski. There he learned his mastery of drum set along with his skills in marching, orchestral, and keyboard percussion. John's skills were further honed with Anthony DiSanza and Dennis Wilson at Kansas State University, along with Steve Hatfield in Wichita Kansas.

Professionally, John has played with various performance groups. Most notably, these include stints with Hutchinson Symphony Orchestra and Crown Uptown Professional Dinner Theater. John's contemporary playing is on display each weekend when he occupies the drum throne at Newspring Church, where he works as a Music Associate in charge of all drums and drummers throughout the campus. Newspring is a venue that has given him the opportunity to participate in two recording projects and has educated him in modern stage performance technology.

John also works as a private instructor in the Wichita area where he teaches at Phatman Drums studios and at the Professional Drum School in Hutchinson. John has also coached with several drumlines in the area including a two-year stint at the Buhler school district.

A master of all drum set styles, orchestral percussion, and marching percussion, John is able to bring his wide breadth of experiences to each teaching situation. Tapping into that knowledge, students can be ensured that they are learning from a true professional, gigging musician.

John is endorsed with Mapex Drums, Sabian Cymbals, and Vic Firth Drumsticks.

www.ingramcontent.com/pod-product-compliance
Lightning Source LLC
Chambersburg PA
CBHW080848170526
45158CB00009B/2671